Little Angels

Little Angels

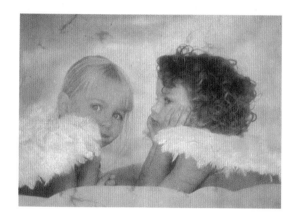

BETSY CAMERON

Villard Books

NEW YORK

1993

DEDICATED TO MY THREE LITTLE ANGELS,

CAMERON, ANNIE, AND CASEY

Published in the United States by Villard Books, a division of Random
House, Inc., New York, and simultaneously in Canada by Random House
of Canada Limited, Toronto.
Villard Books is a registered trademark of Random House, Inc.

Library of Congress Cataloging-in-Publication Data
Cameron, Betsy.
Little angels / Betsy Cameron
p. cm.
ISBN 0-679-75163-7 (alk. paper)
1. Children—Portraits. 2. Photography of children. 3. Angels—
Pictorial works. I. Title.
TR681.C5C34 1993
779'.864—dc20 93-33985

Manufactured in Italy on acid-free paper
Book design by Susan Hood
9 8 7 6 5 4 3 2
First Edition

ACKNOWLEDGMENTS

For all the angels who moved Heaven and Earth in order to create this wonderful book: many thanks go to Connie Clausen for believing, and to Diane Reverand for her vision.

My assistant Randy Handwerger brought sanity to the craziness, while Ashley Van Slyke helped transform the desire into the initial design. A special thanks to my guardian angel, who's there with what my mom calls a lucky star and my dad calls the luck of the Irish.

And, most important, to my husband, Sam Alfstad. He may not be an angel, but he watches over me.

I have to admit, in the back of my mind somewhere, I have always believed in angels. Most people have at least a vague feeling that a guardian angel is watching over them. It's a comforting thought. But when I started photographing "angels" for this book, many friends asked why. It was a good question. Why had I taken my camera, cardboard, and some feathers and dressed up my children as angels?

After some consideration, I think I know.

I believe that children are angels. Because, in a very real way, they are dreams come true. One day you have nothing, and the next moment you are holding the most beautiful thing in the world in your arms. Every child is a miracle. Each one is sent to remind us once again of what *can* be, if only we believe. They say, "I'm possible. Not impossible."

And, after all, what mother has not bent over her sleeping baby and thought, "My little angel . . ."

—Betsy Cameron

Little Angels

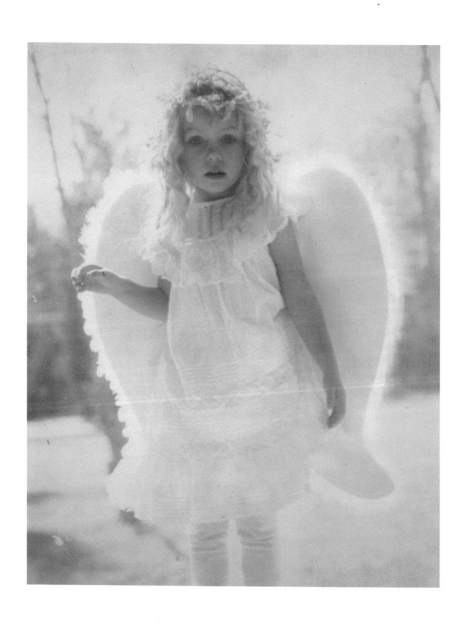

No one ever forgets the first sight of an angel.

—

Angels are only real if

you want them to be.

—

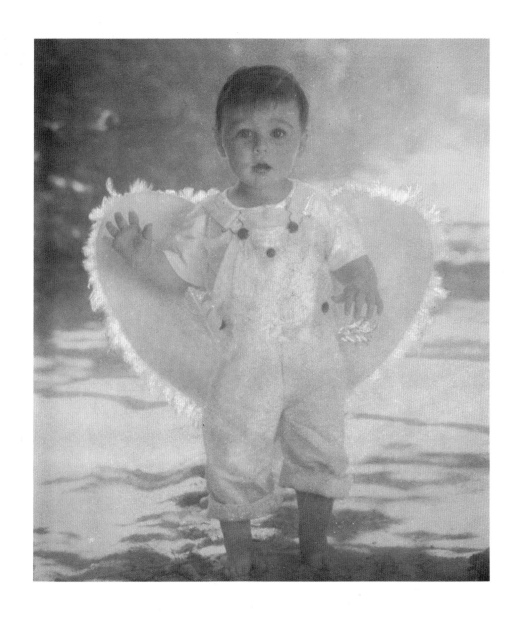

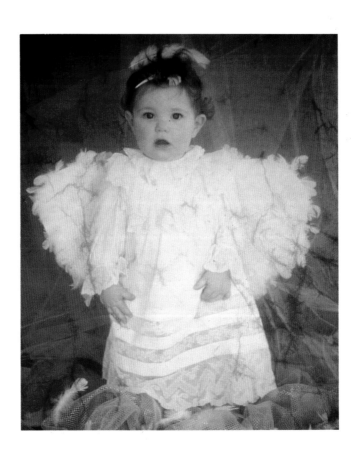

But . . . I believe in *you.*

—

Music is the speech of angels.

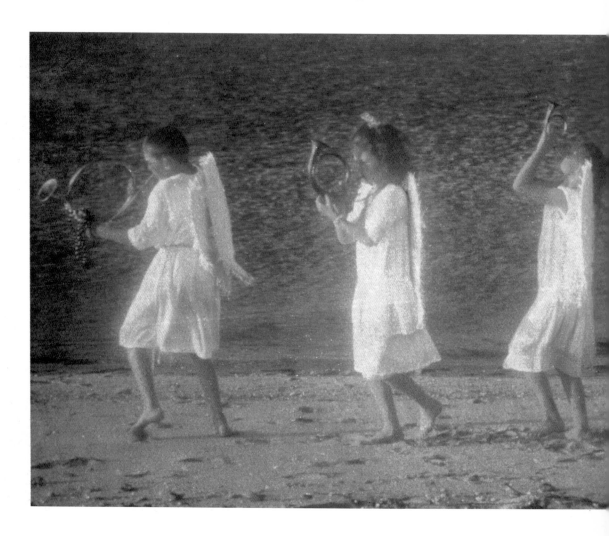

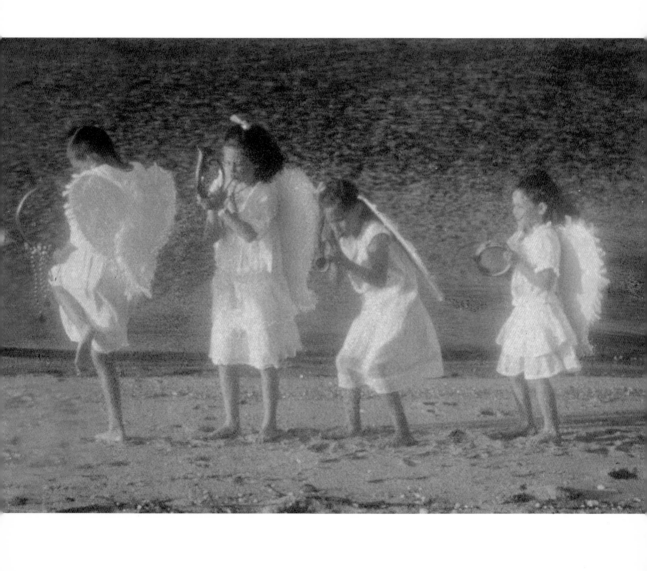

Never fear, angels are near.

———

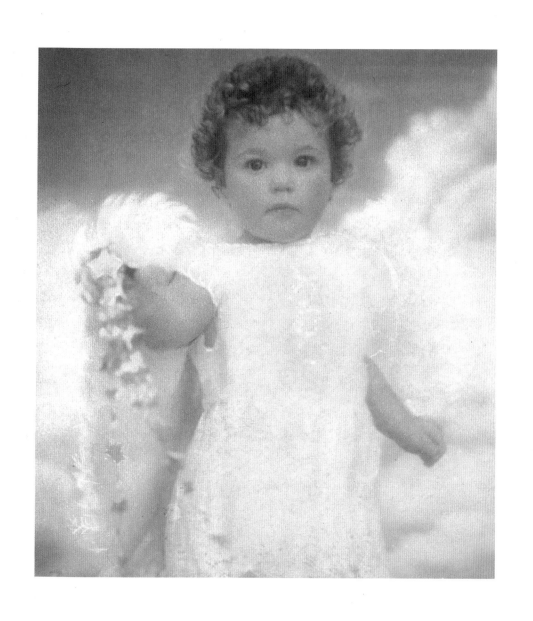

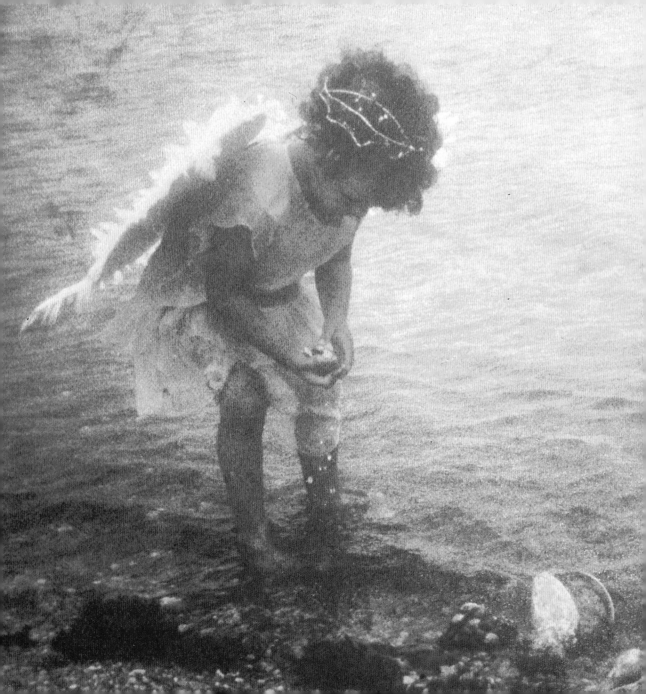

In their search

for love,

angels leave no

stone unturned.

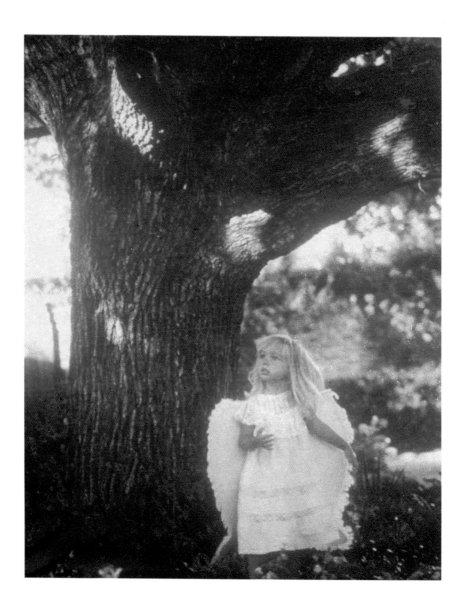

Angels come down to make

dreams come true.

———

Walk before

you run.

Run before

you fly.

———

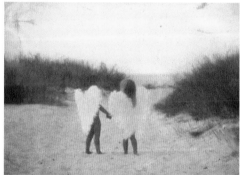

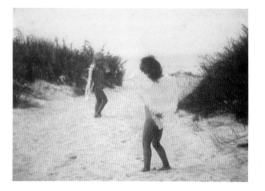

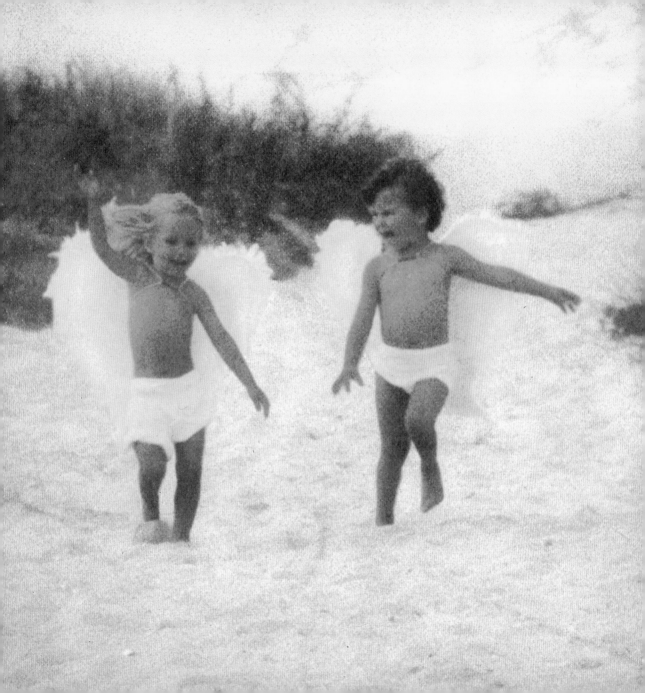

Just the thought of you

makes me happy.

———

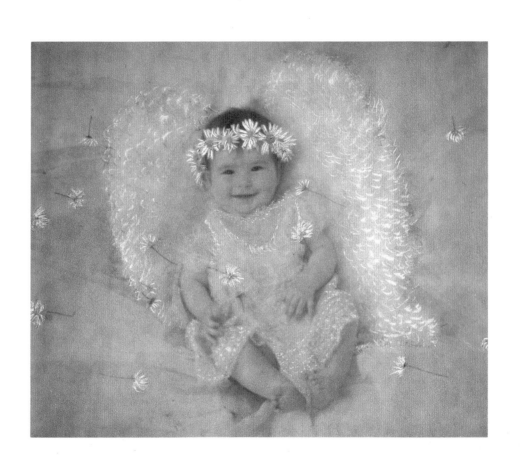

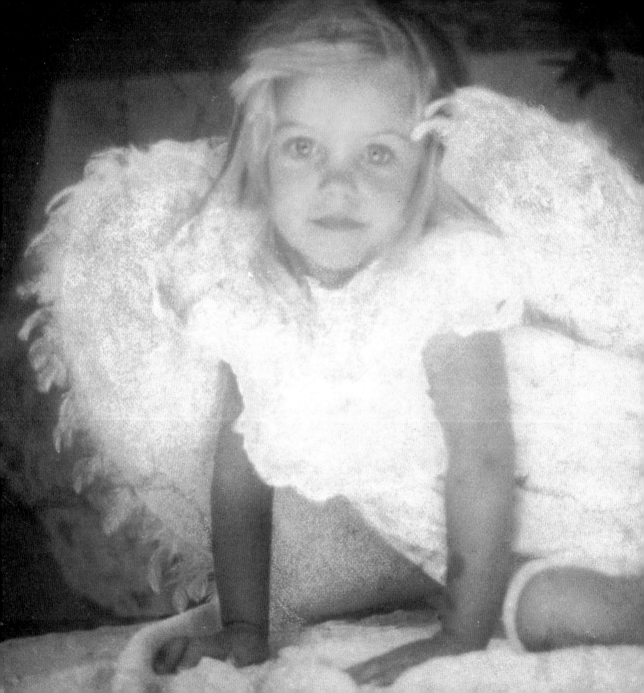

\mathcal{L}et an angel

light up

your heart.

—

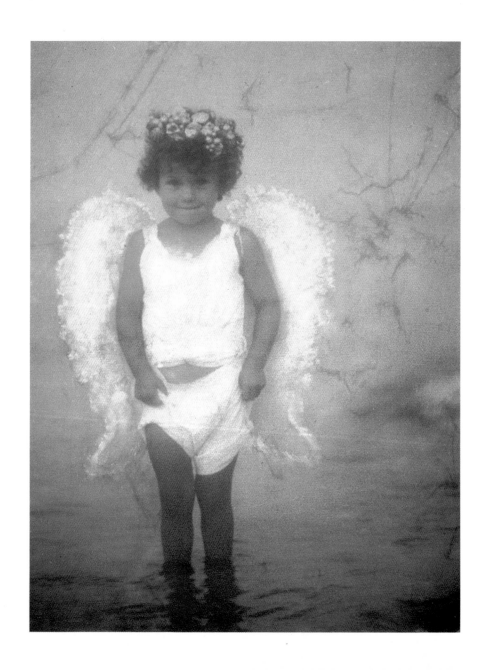

A halo is always worn
with a smile.

———

Ideas are the whispers

of angel wings.

———

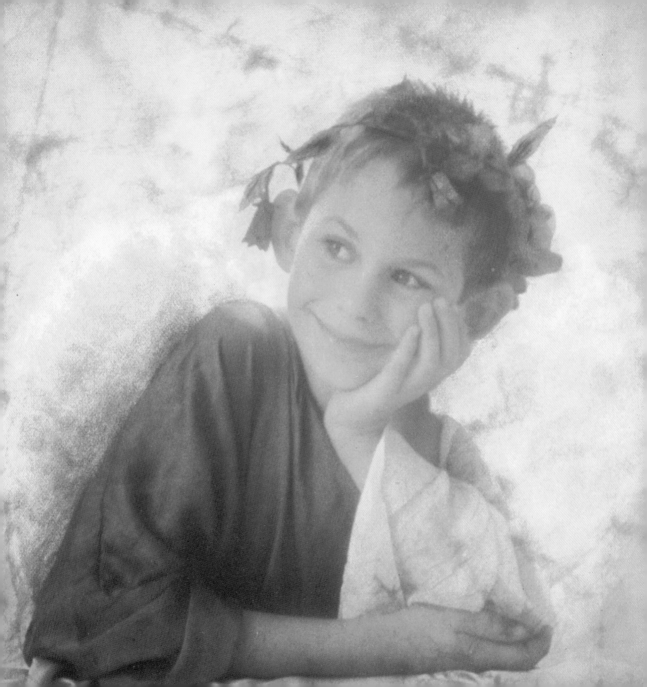

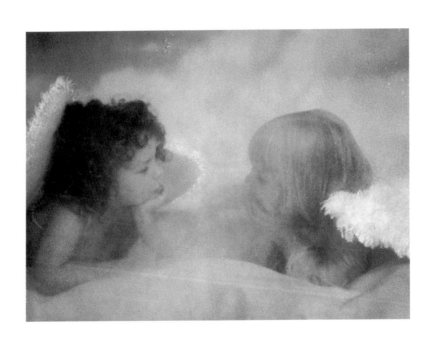

Angels keep love's secrets safe.

———

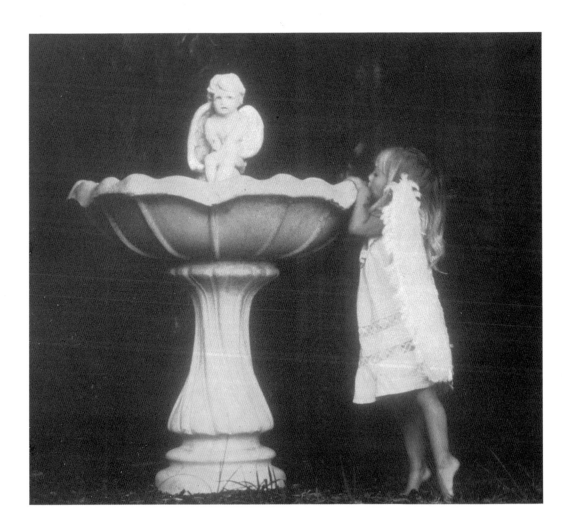

Slowly . . . slowly . . . sip from
the fountain of love.

—

To angels, even the sky's no limit.

—

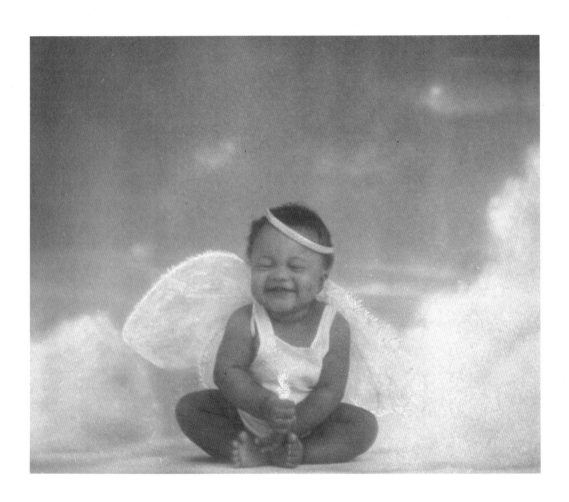

Cupid's delight is love at first sight.

———

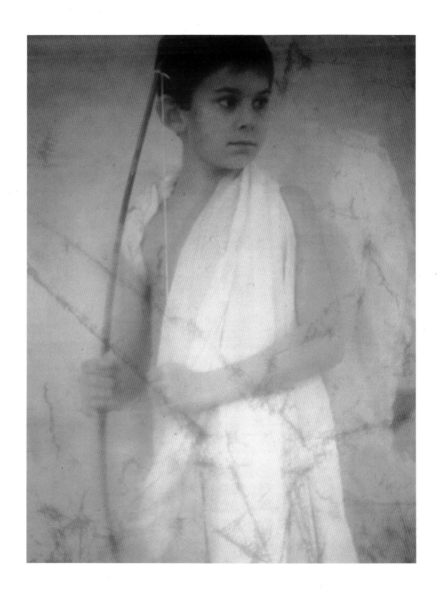

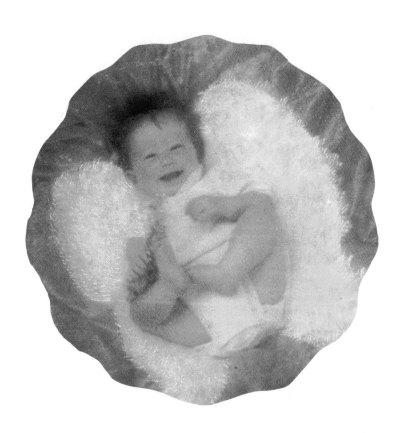

The laughter of angels can

heal a broken heart.

———

\mathcal{B}ecome someone's dream come true.

———

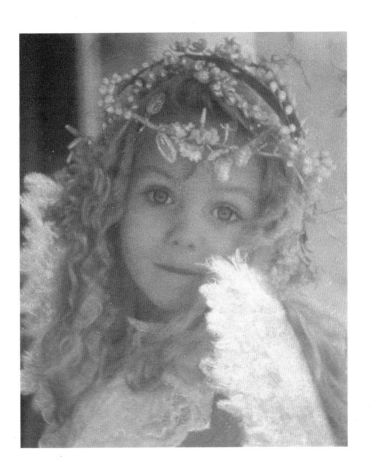

If you ever

lose your love,

I'll help you

find it.

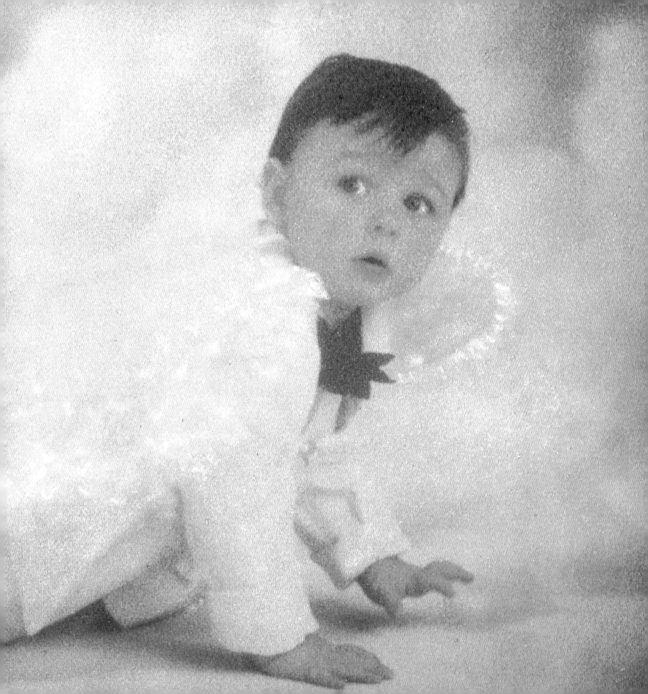

As light as a feather, an angel's

touch lasts forever.

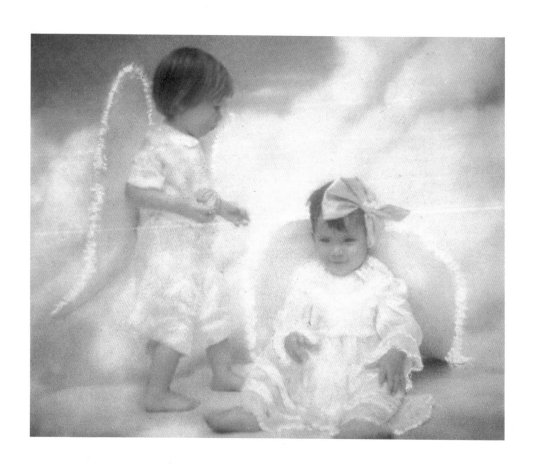

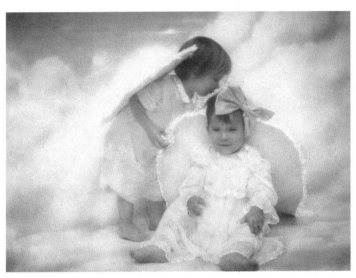

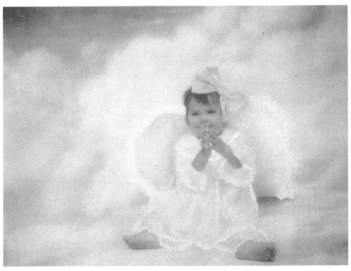

*L*et's make

music . . .

together.

—

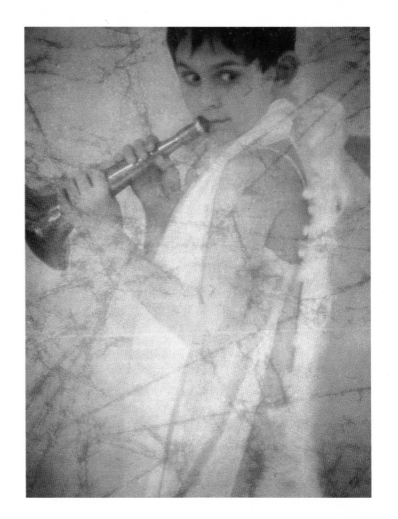

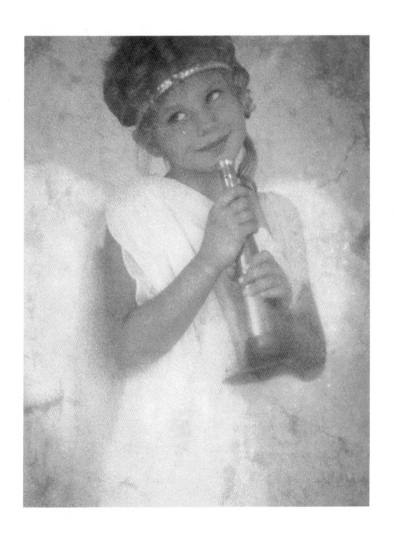

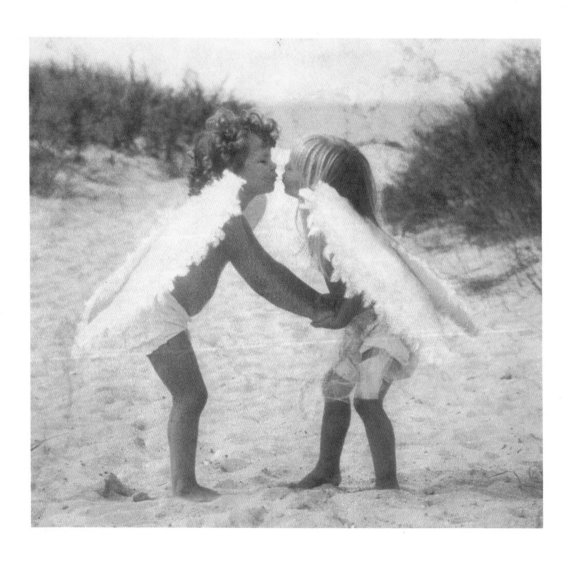

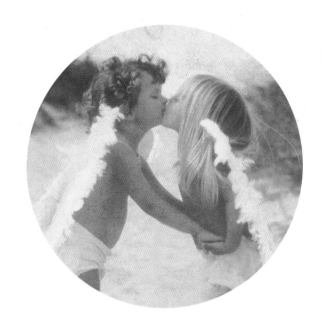

\mathcal{L}ove takes its own sweet time.

The wait is as sweet as the kiss.

———

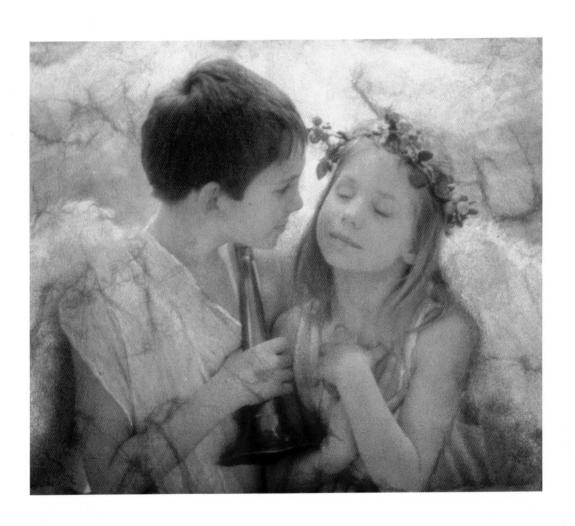

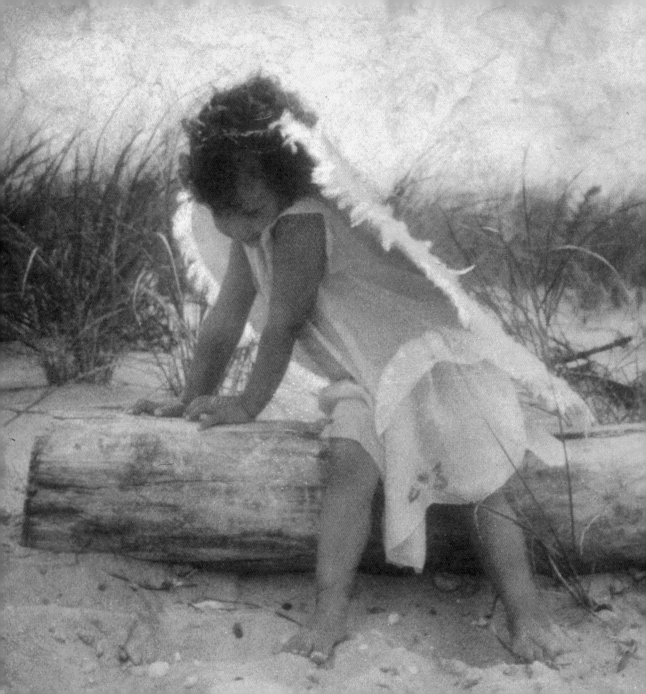

There is always room for you . . .

—

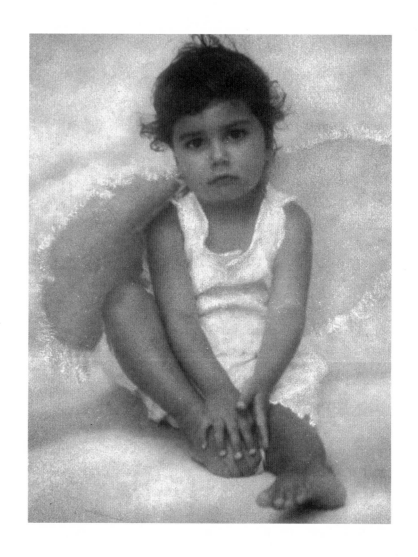

Did you hug your angel today?

—

What are you waiting for?

———

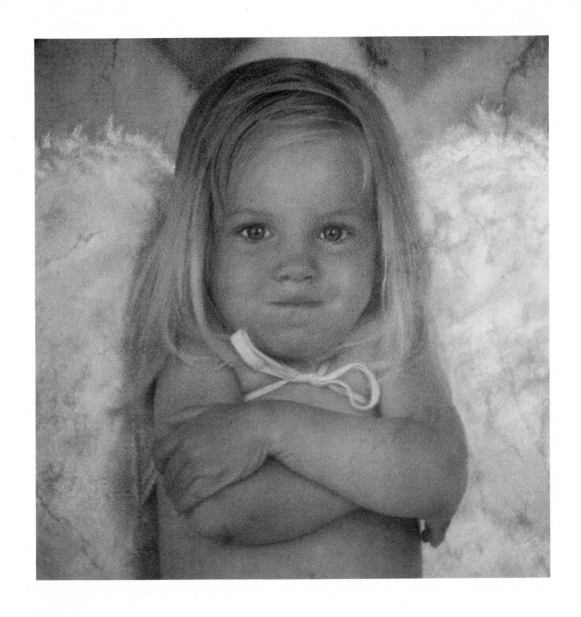

Angels are everywhere—

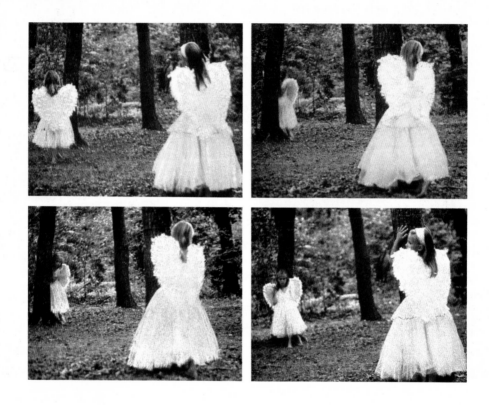

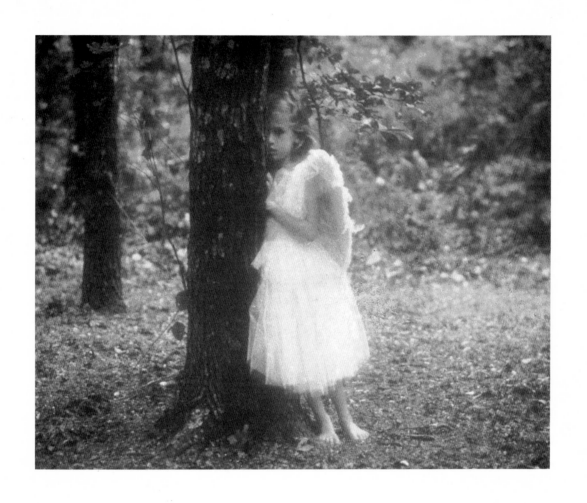

if you believe.

ABOUT THE AUTHOR

BETSY CAMERON began her career as a fashion model, where she had the opportunity to see great photographers at work. She watched, learned, and eventually stepped behind the camera. Today, she is the bestselling children's photographer in the world: her work appears on posters, cards, and calendars. She was named one of *Glamour*'s "Professional Women of the Year," and has been the subject of articles in *Harper's Bazaar, Working Woman, Good Housekeeping, Confetti, Child, Text,* and *Victoria*. Betsy lives in East Hampton, NY, with her husband and three "little angels."